LOVE IN AN

ALIEN

PURGATORY

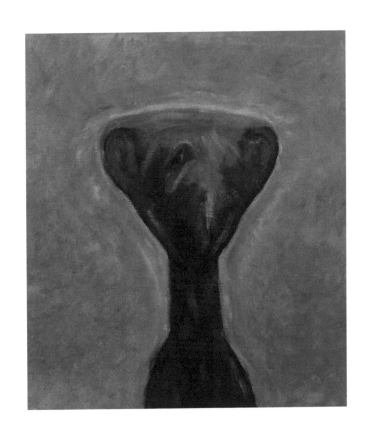

LOVE IN AN ALIEN PURGATORY
The Life and Fantastic Art of David Huggins
By Farah Yurdozu

Anomalist Books
San Antonio * New York

An Original Publication of ANOMALIST BOOKS

LOVE IN AN ALIEN PURGATORY
Text and Photographs Copyright © 2009 by Farah Yurdozu
ISBN: 1933665432

Cover paintings by David Huggins:
Glowing Eyes, April 1989, 24" x 54"
Detail from *Leaving the House*, February 2008, 28" x 32"
There's Something About the Moon, April 2008, 20" x 60"

Book design by Seale Studios

For information, go to anomalistbooks.com or write to:
Anomalist Books, 5150 Broadway #108, San Antonio, TX 78209

Contents

To my mother, Taylan Bayraktar, my dearest one.
And to Richard Day Gore who has always been a tremendous help.

Introduction

David Huggins has lived, loved, and been guided by extraterrestrial forces all his life. He is one of the chosen ones, an ordinary man whose alien abduction experiences started when he was a little boy. In this parallel universe, the aliens have given David their love and passion. In return he has given his youth and his innocence, as well as something else very tangible – more than 60 hybrid children. Through the years he has met his alien guides in a special place between two worlds—not a paradise, nor a hell, but a purgatory of questions, hopes, miracles, and fears. This alien purgatory is the stage for his remarkable story.

I first met David at a New York City UFO meeting in 2002. As alien abductions and close encounters with extraterrestrial beings are my field of research, I was very interested in David's story. When I saw David's paintings I immediately recognized the familiar abduction-contact pattern that is typical of UFO lore. David's paintings show someone who was being visited by the Grays and Hybrids all his life, with contact continuing to the present day. They are works that inspire awe in some, skepticism in others. But as I talked with David at that meeting, one thing became clear to me, as it is clear to others who know him well: whether or not the viewer believes that his paintings are based in concrete, physical reality, they do in fact represent David's personal reality as it exists in his mind and emotions. Of course, the nature of the reality they depict is up to the viewer's interpretation, belief, or prejudice. But what is certain is that David Huggins is sincere. He doesn't need people to believe, and he understands that many simply don't. As David once told a reporter, "When you know something, you know it, and these paintings are the result, and whatever you think is what you think."

After meeting David, I was surprised to learn that we live in the same town and are neighbors. There, David is a familiar figure: an unassuming man who works in a local deli and lives in an ordinary house with his wife and son. For all appearances, David Huggins is like anyone else as he goes about his everyday life. He shops for necessities. He chats with neighbors and passersby on the sidewalk and with customers and coworkers in the deli. He goes to the local post office, the coffee shop, and the bank. He is everyman. But that's the essence of the alien reality: the individuals who have the extraordinary experiences like David's are "normal" members of society—our neighbors, our friends, and, sometimes, ourselves.

When David began recovering the hidden memories of his alien encounters in 1987, he decided to document his experiences in the ever-growing collection of paintings that appear in this book. It is a pictorial autobiography: a life story of a life lived in the most unusual way. It is a story peopled with characters such as Crescent, the hybrid woman; the Tall Insectlike Being; and Little Hairy Guy. There are many side characters as well: a group of Gray aliens and other Hybrids who have been present during his abductions and who people his paintings. They have always been with David, all of them.

Enthusiasts of UFO and abduction lore will be familiar with some of the concepts documented by David in his vivid and sometimes disturbing images. What are called "alien abductions" became a part of the field of UFO investigation in the 1970s with the testimonies of thousands of women and men claiming that they were taken from their homes by extraterrestrial visitors. Although we still have little evidence indicating that these visitors are from another planet, it is reasonable to assume that they are coming from another realm that is completely different from our earthly physical reality.

Short of actually witnessing an encounter, there are two basic ways to gather information about abductions and alien visitors: from conscious memories of the abductees and the information they share while under hypnosis. In both ways abductees give detailed information on advanced flying crafts and technology we call UFOs and Gray and Hybrid type beings performing medical or genetic type procedures on the humans. Under hypnosis, almost all abductees recall that they were given implants by extraterrestrials. These tiny metallic objects are generally placed in the nasal cavities, inside a bone, or in the head of the abductees. In United States, a group of private abduction investigators and surgeons have been conducting detailed investigations on removing these alleged alien implants. These implants are said to be used to monitor abductees' emotional and physical states. As you will see in these pages, David was given an implant in one of his early encounters with his otherworldly visitors.

Although David's story is similar in many respects to other close encounter or alien abduction experiences, his case is also different. For example, David's visitors never gave him spiritual, philosophical, or semi-religious cosmic messages, as they do to so many others. They never promised that they would save humanity from an upcoming worldwide disaster. They never suggested that David practice meditation or use crystal healing methods. It seems that David's alien contacts were not very interested in the "New Age" trappings reported by others. They certainly didn't promise him paradise.

Far from it. They kept him in a constant purgatory, using him for something much different from spreading messages of peace. Since the beginning, they made it very clear what they wanted from David. Whether it was a cosmic mission or not, what they needed was David's body for the breeding of a new hybrid race, with Crescent as the recipient of his seed. The relationship was based on sex and the continuation of a new race.

As he documents in his paintings, there are three main periods that shape David's life with the alien visitors. As far as he remembers, the first contact started when he was an eight-year-old boy living in Georgia. It was 1951, a time when the general public didn't have a clear idea about ETs, and knew absolutely nothing of hybrids and alien abductions. Many close encounter cases of this era were forgotten or ignored because of fear and prejudice and lack of information. Perhaps David's story demonstrates another reason there are so few abduction reports from this era: ET visitors usually want their human abductees to forget the abductions and are good at making this happen. And this is exactly what happened with David. The ETs first wanted him to forget everything, giving him a specific date when the memories would return. And eventually they did. Those memories form the tapestry of amazing images you will see here.

One unusual aspect of his story is that many of David's early ET encounters happened during the day, when he was playing in the farmland around his house. He was totally awake, running, jumping as a healthy boy would, not sleeping or in a state of paralysis as reported by most UFO abductees. Though they might have introduced themselves to him in the daylight hours, they continued to visit at night, when they would come to his bedroom and take him to a flying craft. David recalls that he was taken to an egg-shaped metallic craft countless times, where he was able to see the earth in the distance from a window.

But regardless of similarities or differences to other close encounters, one thing is certain: David's young life was traumatized by beings and occurrences that were utterly foreign to him. What many kids only see in the comic books or in fantastic movies became a daily part of David's life. Just as in many abduction cases, David never said anything to his parents about the visitors. This was a part of the usual "You are not going to talk about us" conditioning by the ET visitors. He was truly alone with his disturbing reality. His paintings vividly capture the fear and isolation that came to pervade his world. He forgot this fear after his experiences, but perhaps it still motivated him unconsciously.

David's first period of abductions ended when he was eleven years old. When the aliens came back into his life, he was seventeen. It was now obvious that Crescent didn't want to share him with other women, and the more innocent-seeming, hide-and-seek games of his boyhood encounters were replaced with something much more serious. David was now introduced to sexual intercourse by Crescent. He, in fact, lost his virginity to this being from another world or dimension.

Why did these beings choose David out of the millions of candidates for their attention on Earth? Perhaps David's rural environment, far from the city, made their work easy. But as David's paintings show, he was to learn that his location made no difference to them. When he moved to New York City to pursue an education in art, they found him there too. And this time the contact was deeper, more intimate and intense than ever. They were in his life, in his home, and in his mind constantly. They even left physical traces to prove that they were real.

Between 1963 and 1971, David had two or three encounters with them each week. Now a completely new phenomenon took place: instead of taking David to some other location, they started to visit him in his New York apartment, arriving and departing through what David presumes was some kind of interdimensional gate that appeared on his wall.

Now an adult, David had many questions about his visitors, but they offered no answers. They never told David anything about their origin, either in name or detail. He doesn't know if they are from another planet or another dimension. In some of his encounters, David got the impression of being in an underground cave complex. He has memories of traumatic experiences with Crescent and the other hybrid beings in this subterranean place. But David's feelings of pain and suffering also had a traumatic effect on the aliens. They seemed very surprised to see human reactions such as sadness and grief. When David banished his feelings of sadness, he experienced a surprising reversal of emotional roles when he was compelled to have sex with two Hybrid

women and teach them the human emotions of tenderness. When David exposed his feelings, whether positive or negative, the aliens observed him carefully as if they were learning human traits.

Although David had no conscious memory of these emotions after each encounter, fear, isolation, sadness, and depression are familiar feelings for many abductees. The controlling power of extraterrestrial visitors may vary from case to case, but it exists in different degrees. Sudden depression, fear and phobias, and sexual problems may easily develop and overwhelm the abductee. It is quite telling that David started to experience his deep depression *after* recalling his encounter memories.

Abductees like David often experience private lives that are marked by relationship and marriage problems. It is as if someone or some force doesn't want abductees to have a happy, healthy love life and fulfilling relationships. Their efforts at happiness often seem blocked; they feel controlled and pushed to loneliness. Alien visitors want to be the first priority in the abductee's life, and Crescent made this quite clear to David.

David's story of otherworldly relationships and worldly personal turmoil is part of the folkloric traditions of many cultures stretching back to ancient times, and it fulfills a pattern that many see as evidence of alien contact millennia in the past. For example, in the jinn legends of Turkey, children are "taken" to another dimension by nighttime visitors of great metaphysical power, the jinns. Later in life, many jinn contactees tell of having ongoing sexual and sometimes emotional relationships with jinns, which often produce hybrid offspring.

David's relationships with Crescent also brings to mind the ancient incubus-succubus legends. Incubus male and succubus female demons who visit sleeping humans and have sex with them were first mentioned in Sumerian texts. These interdimensional beings were represented as gods and demons who were not able to conceive children. They needed human genetic material to continue their own race by having hybrid babies from Earth men and women.

David's cycle of experience with the aliens is, in a way, a fulfilment of these ancient traditions of interdimensional gene-mixing. But David has an earthly wife (now divorced) and son as well. After the New York City encounters, Crescent and her alien companions apparently left David alone for almost twenty years, during which he remembered nothing of his many interactions with them. Then, as happens with many abductees whose memories have been erased or blocked, he encountered an object that triggered the return of his memories, actually a torrent of memories that continue to manifest themselves as paintings.

Although David's contact with his visitors continues today, it is not as intense as it was in the period from the 1960s to the 1980s. Though he no longer needs to father more hybrid babies, his relationship with Crescent has deepened into a lasting friendship. In a recent encounter depicted in this book, Crescent gave David a very precious gift: his hybrid child. Crescent's face shows the pride of motherhood. But it also bears the expression of a scientist who is satisfied with the result of a lifelong experiment.

My close proximity to David has given me access to his studio where the works in this book were created, and we have had many conversations about his experiences and the realm of ETs. Though he has been aware of his experiences since 1987, he has preferred to keep a safe distance from reporters, writers, and other curious people. Some close friends are aware of his experiences, but David shows no interest in broadcasting his unusual life story except through his art. David's story has never been studied by any of the well-known alien abduction experts. He has tried neither hypnotic regression nor therapy in order to find out more about his memories.

In the last six years David's experiences with Crescent have inspired an interest in science fiction and other fantastic movies, something he never paid any attention to in the past. He now owns hundreds of movies, from obscure black and white rarities through the classics to modern, popular sci-fi. Maybe David is looking for something: an answer, a familiar face, pieces of his erased memories. But for now, at least, the answers lurk within his mind.

With these paintings, David Huggins shares his story with us: one man living in a unique space between two lives, an alien purgatory that he can't escape. And so it is with the love and passion he has for them. But isn't that what love often is: a purgatory between two worlds, a place of desire between hope and fear?

MEMORY LEAKS

The Drawings

David's home studio is also his exhibition space. Artwork is stacked in every room. One day, David showed me a few sketchbooks that he had found by chance in his basement. He had forgotten about them. They are filled with black and white drawings from the early 1970s – a time when David wasn't aware of his contact experiences. Among the mostly mundane subjects appearing in these sketchbooks are some UFO-like objects (below), and (next page clockwise from top left) two figures with some distinctly alien features; a human body study with the head of a Gray; a sketch of a Latin American man with an out-of-place alien head; and what appears to be a dream-like female figure with open arms. The story that follows is what emerged when David began remembering his experiences in 1987.

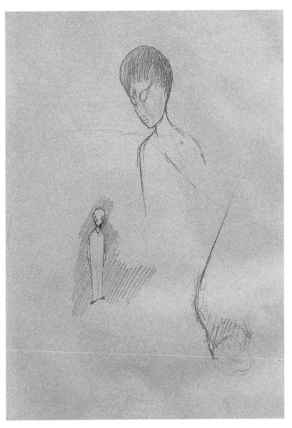
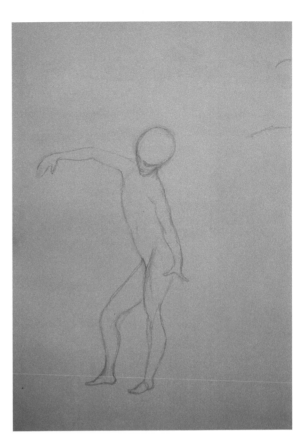
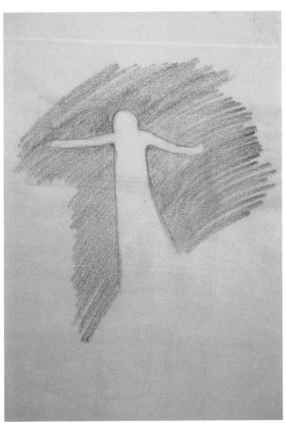
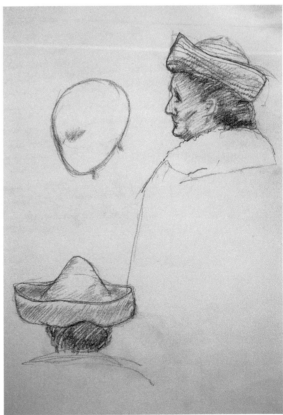

CHILDHOOD ENCOUNTERS

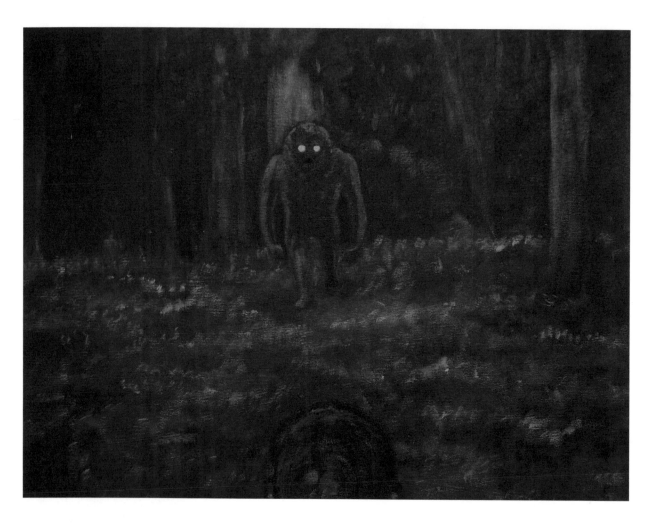

The First Meeting

David's first experiences with the visitors from an unknown realm started when he was eight years old. It was the summer of 1951. He was living on a farm in the Georgia countryside. On that day he was playing by himself around a tree near the barn when he heard somebody say, "David, behind you!" He turned back and saw a short being with thick, dark brown colored hair coming closer to him. When he looked at the creature's large, glowing eyes, David, scared, found himself unable to move. Eventually, he escaped. Later in the afternoon he returned to the spot where he had seen the creature, and yes, it was still there. It came out from the trees and looked at him. Terrified, David ran back into the house. For some reason, he never said anything to his parents about the incident and promptly forgot about it. But it was not the last time David would see the creature he called the Hairy Guy.

The Owl in the Tree

That same night, David woke up in middle of the night. When he looked out his window, David noticed an owl with very large glowing eyes on a tree just outside of the window. The owl was looking directly at him, and David stared back at him. The rest of the night David's mind was occupied by a very strange dream about a group of tiny men coming in his room. When they got close to his bed, the dream ended. The dream was repeated the following nights.

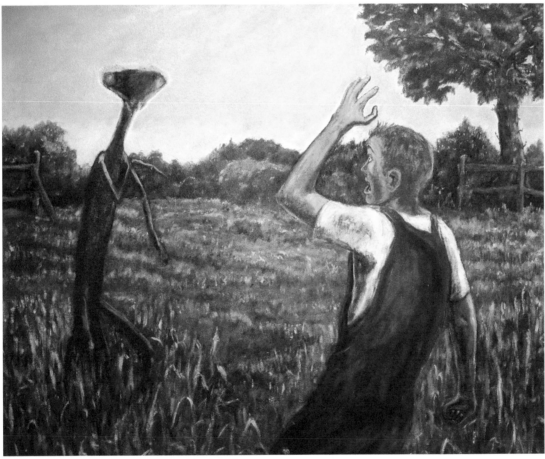

The Insectlike Being

One afternoon David came to the barn to get his softball. When he heard a scraping sound from the other side of the building, he walked around and was shocked to see what awaited him: a giant praying mantis. It looked at David and sprayed a bluish-grey liquid on him. He jumped back and escaped screaming. It did not follow him. Still shaking with fear and his heart pounding, David noticed that the blue fluid had left no stains on his shirt and pants. He would later see the Insectlike Being many more times.

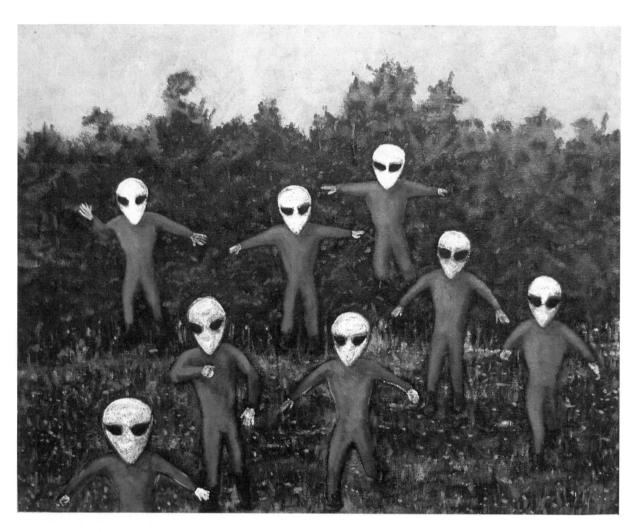

Eight Floating Grays

David was amusing himself looking for arrowheads in the field in the back of their home. Suddenly he looked up and saw eight little Gray beings wearing blue jumpsuits, slowly floating down from the sky. They had large heads with almond-shaped black eyes. After landing gently on the ground, they ran towards him. David panicked and started to run home. When he looked over his shoulder, he watched the group of Grays suddenly disappear into the air, becoming invisible as if they were behind a curtain. The young David thought this was very good magic trick. This was David's first daytime experience with Gray aliens.

LOVE IN AN ALIEN PURGATORY

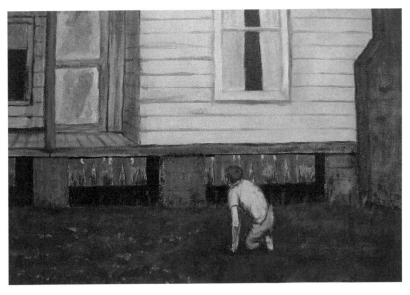

Five Pairs of Blue Legs

Like many houses in the area, David's family home rested on cinder blocks, creating a crawlspace about three feet high beneath it. David hid on the opposite side of the house from the strange visitors. Eventually, they walked up to the house and stayed there a while. He was able to see their legs. After a short while, they turned and walked away. David went to his bedroom and looked from the window. The field was empty, and the visitors were gone.

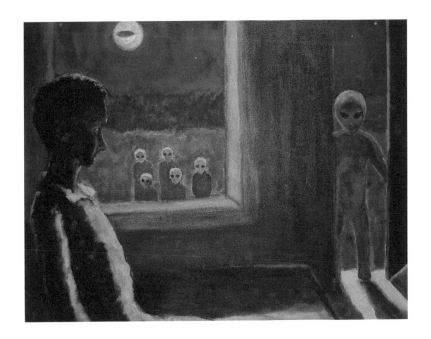

Night Time Visitors

Later that night, David awoke with a start. Through his bedroom window, he saw a big UFO hovering in the air just in front of the full moon. A group of Grays were standing outside looking at him through the window. When he made eye contact with them, he suddenly felt his fear melt away. One of them walked up the steps, opened the door, and came inside.

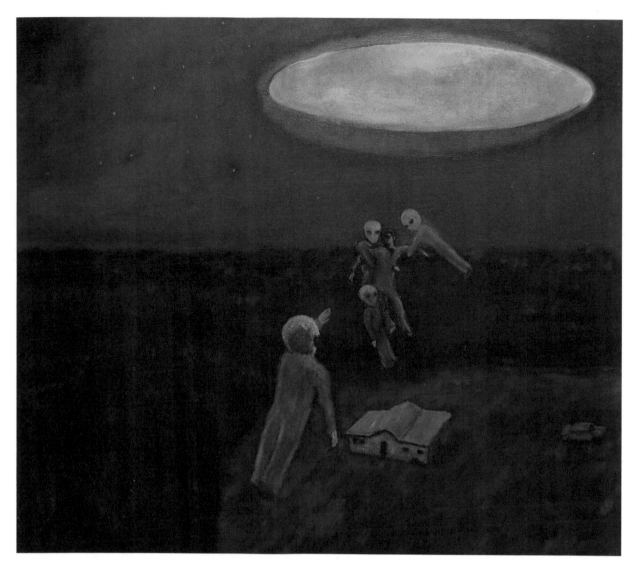

Time To Go

They came to take David on his first journey of what would become an incredible lifetime adventure. David remembers being held by three Grays who carried him smoothly and easily into the air. One other escorted the group, as if directing them. David looked down to see the house, trees, and fields getting smaller and smaller. Above them in the sky, the huge oval object waited for them. David didn't see any doors or windows on the surface of the glowing UFO. Then, without David being aware of how it was done, they were suddenly inside the craft.

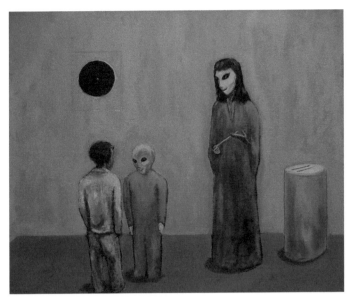

First Meeting

David found himself inside a large, metallic looking room. It reminded him of a doctor's office. He was next to a short Gray being whom David believed to be a little boy just like himself. And there was a woman too. She had both human and alien features. Later, David would call her Crescent. David looked at them and asked the Gray being: "Is that your mom?" Both the Gray alien and Crescent smiled silently. David noticed a long, thin tube in Crescent's hand. There were two more tubes on a stool behind her.

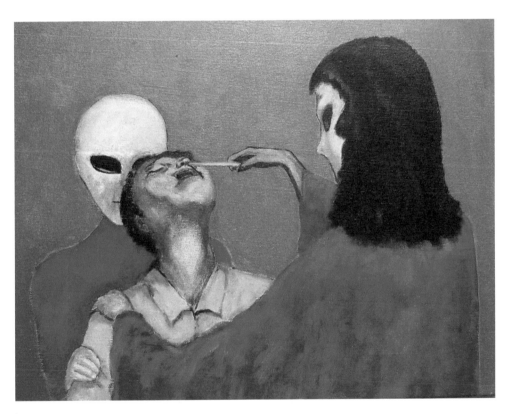

Implant

The Gray being took hold of David's arms and held him as Crescent inserted the tube into his nostril. There was resistance, so she pushed it hard. Something in his nose gave way with a crunch. She removed the tube and the Gray let David go. David started crying: "You hurt me! You hurt me!" When Crescent began to rub his nose and David looked into her eyes, his fears disappeared and he stopped crying. She leaned towards David and he was momentarily aware that she was removing the memory of this incident.

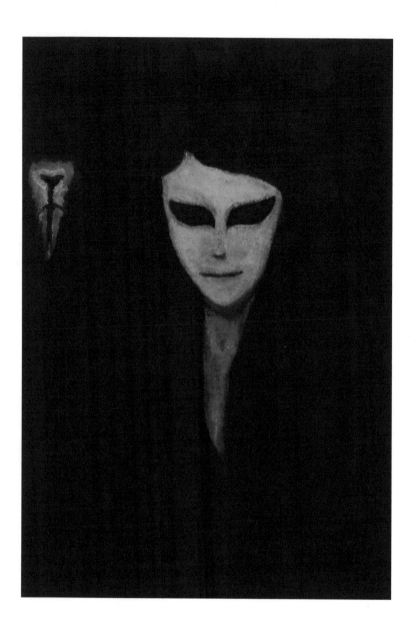

Crescent

David believes that Crescent is a hybrid being. With her pale skin and large eyes, she has both alien and human features. She has a small nose and thin lips, and her hair looks like a wig, as if she is affecting it for the sake of appearing more human. David thinks that Crescent is an old being, with a very old soul. Crescent would eventually become David's protector, guide, teacher, lover, and, later, the mother of many children they had together. David became hers in every meaning of the word, as she led him through the alien purgatory of his secret life—a life that for years was secret even to him.

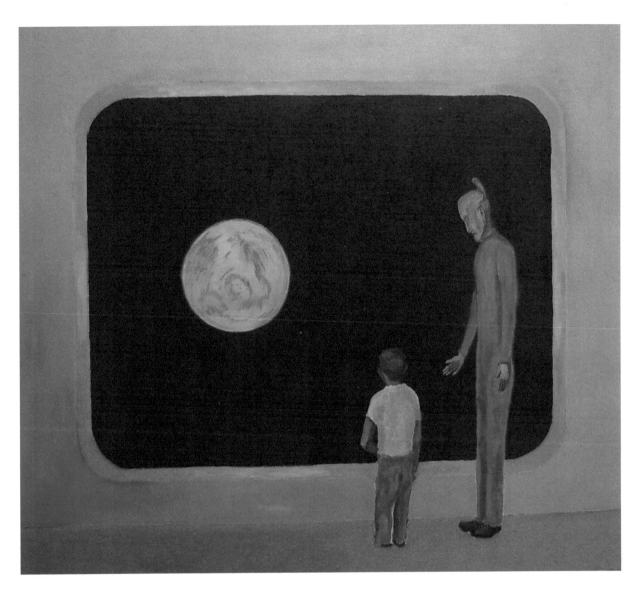

Watching the Earth

That same night David met another being in the UFO. This tall, almost human-looking man gave David an impression of authority. He took David to a large window; the Earth was visible in the distance. The being talked about the Earth, space, and space travel. This image was the last memory of David's first otherworldly trip. He doesn't remember how he got back home. The next morning he woke up in his bed with a slight nose bleed.

LAST DAYS IN GEORGIA

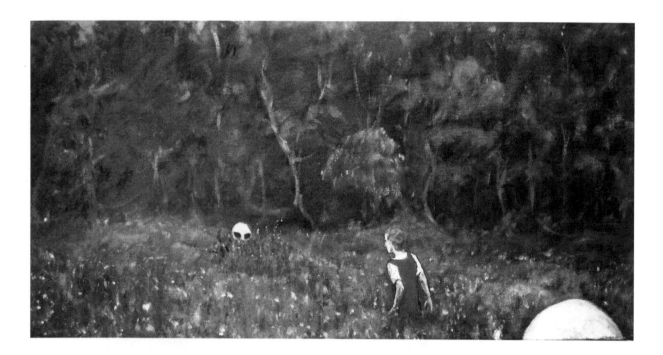

Between Two Grays

After that first experience, weeks passed before anything else happened. Then one afternoon David was on his way to visit a friend, when he felt he was being watched. He stopped and saw, not far from him, the top of a head behind some bushes. As the being continued to reveal himself, David saw that it had a big head, very large black eyes, thin mouth, and small nose. David then noticed another being behind him; he was caught between them. The scene was suddenly bathed with bright light, and David's mind went blank.

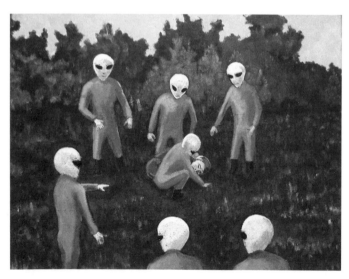

Missing Time

When David came to, he was on the ground, curled up in a fetal position. He opened his eyes, saw seven Grays around him, and heard three very high-pitched electronic beeps. Then, suddenly, the visitors were gone. David found himself in the middle of a field, far from where he had been. His mother had been searching for him and calling his name. She was worried because he had been gone for an hour, and his friend was still waiting for David to come over.

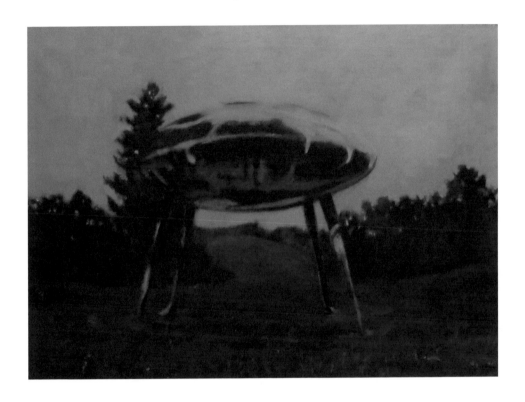

Landed

UFOs became regular visitors in David's life. One landed in a field behind his home. He still remembers vividly the shiny, mirror-like surface of the metallic UFO.

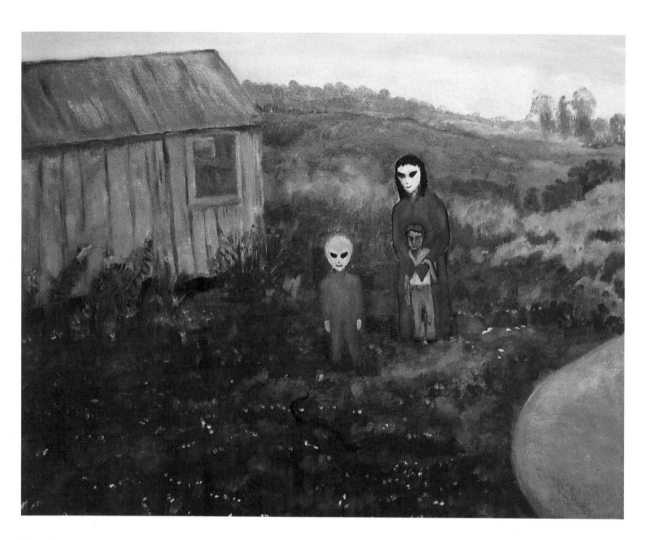

Snake

David's mysterious visitors were always around, often protecting him. One day, as he was about to play under a tool shed close to home, a Grey and Crescent appeared and warned him off. The three of them watched as a large black snake came slithering out from under the shed.

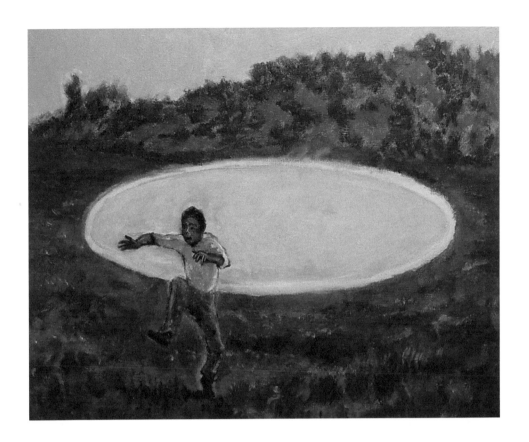

Hide and Seek

Far from the crowded city, in rural Georgia, David was always the only eyewitness to what was happening. One ordinary play day turned into a terrifying game of hide and seek. "I was chased by an oval light," David recalls. "This is all I can say." He ran in fear. Then, a moment later, the object was gone.

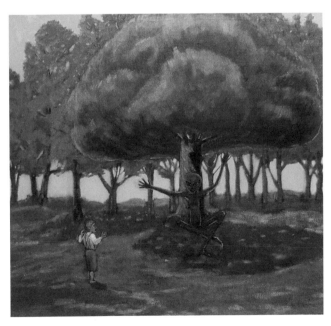

Welcome, David

"She was waiting for me under a tree," says David about a tall, dark-skinned being. Still not used to these encounters, David reacted with terror. He knew somehow that "she was a female when she opened her arms welcoming me. There was something special about her." She didn't come closer to him but sat silently watching him.

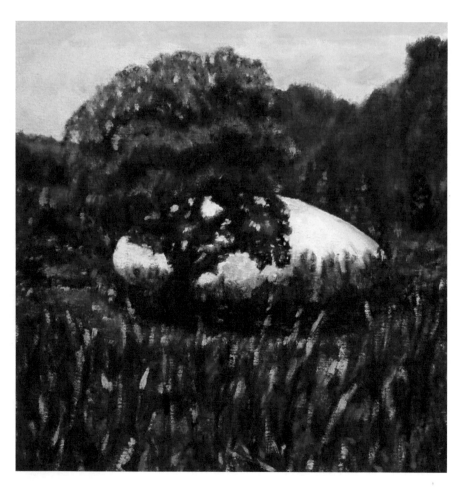

Egg Shaped UFO

David saw an egg-shaped UFO on the ground behind a tree. He walked closer to the object. He didn't see any doors, windows, or openings of any kind on its surface. But as he took one final step toward the object, he suddenly found himself inside it.

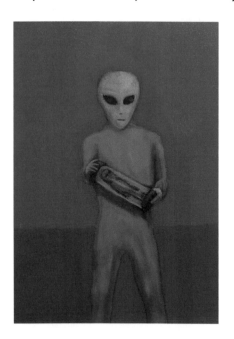

Baby In The Tube

Inside the craft, a Gray alien David had seen previously was waiting for him. He was holding a glass or plastic container in his hands. When David got closer he saw a very tiny Gray baby inside the container. The alien wanted David to look at the baby carefully. David didn't understand then, and he still cannot comprehend why they showed a baby to a 10-year-old boy.

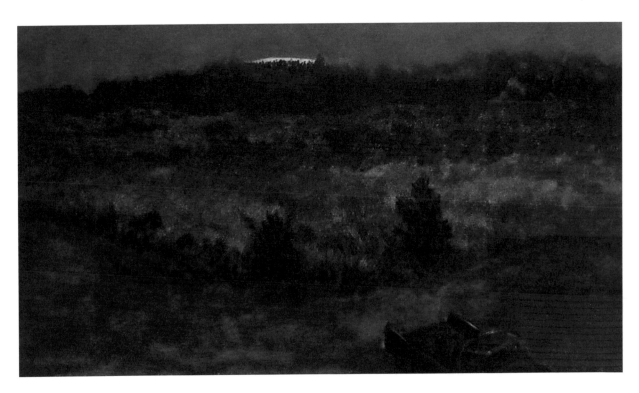

Moving

When David was 11, his family moved from their home in Pauldin County to a new one in Acworth, Georgia. It was late at night when they drove off in their truck with the last load of household goods. David was sitting in the back. As he watched his childhood home recede in the distance, he saw something else: a UFO following just beyond the tree line. He didn't say anything to his family. David doesn't recall any further significant encounters with his visitors until he was 17.

THE FIRST TIME

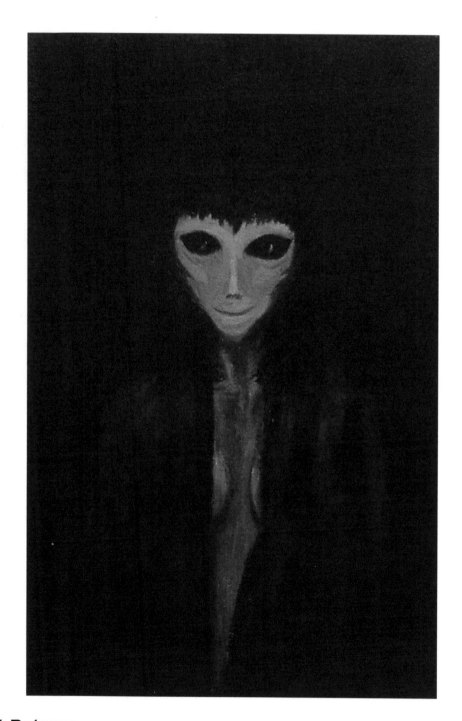

Crescent Returns

The hybrid woman played a very important role in David's life. When he was 17, Crescent came back. But this visit was much different from the earlier ones. Crescent and the other aliens were preparing David for something. But he had no idea what it was.

LOVE IN AN ALIEN PURGATORY

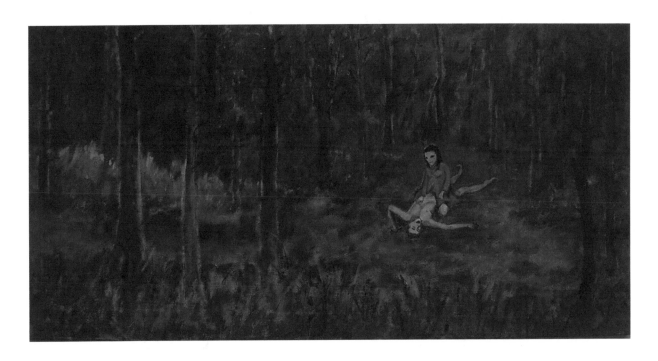

The First Experience

David began to discover the meaning of these encounters on a very hot summer day when he went to swim with friends in a nearby lake. To avoid the summer sun, he took a path through the cooler, shady woods. Suddenly he saw Crescent sitting under a tree. David was scared, but his fear was soon supplanted with a new feeling: sexual arousal. He couldn't move. Crescent walked towards him and told him to lie down. David took off his clothes without saying a word, and the last thing he remembered before passing out was how close Crescent's eyes were to him. This was his first sexual experience. He woke up 15 minutes later, but it would be years before he had any memory of the experience.

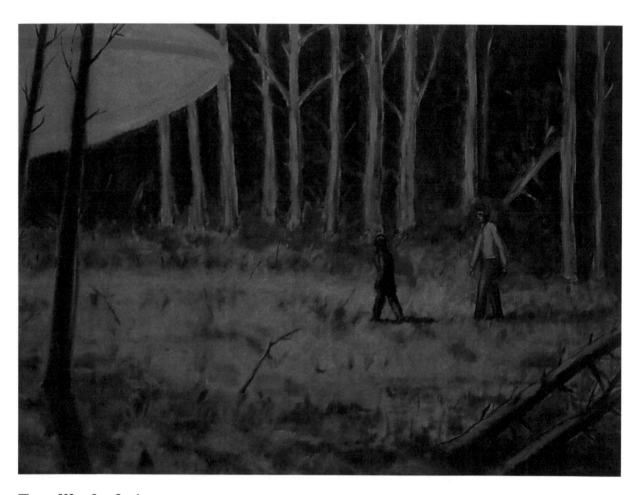

Two Weeks Later

Two weeks later, David awoke one night and saw his earliest visitor, Hairy Guy, next to his bed. The visitor told him to get dressed and come outside. David obeyed and they walked together towards the woods. There, David saw the egg-shaped UFO among the trees. Approximately 15 feet long, the object emitted a softly pulsating glow.

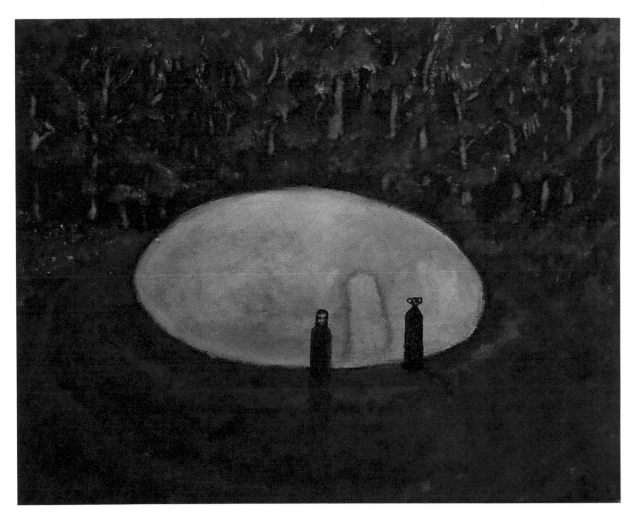

Waiting for Me

As they approached the UFO, David saw that Crescent and the Insectlike Being were waiting for him by the object. David went inside with the others. He doesn't remember what happened then; before he woke up he was given the instructions not to remember anything and his memory was erased.

THE BIG APPLE

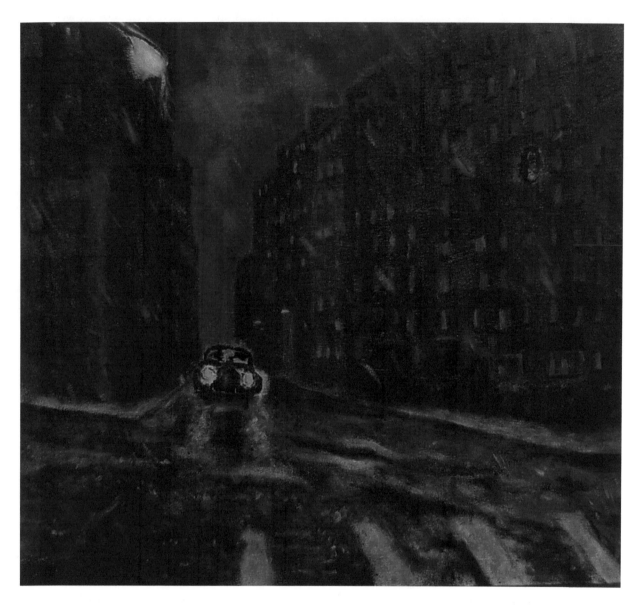

New York City, 1965

At the age of 19, David moved to New York City to study art. He quickly adjusted to the busy city life and the college environment. He started to date a young girl from his school. Everything seemed normal. But his quiet student life was about to change drastically.

David got a job at a hardware store. One Saturday afternoon while he was organizing the shelves, a man and a woman entered the store. Actually, rather than enter fully, they stood by the door and stared at David. He stopped what was he doing, walked towards them, and asked, "May I help you?" They didn't answer. Their eyes had a hypnotic effect on him. David repeated

his question but again got no reply. David found their attitude very disturbing, but before he could speak again, they turned and hurried out the store without uttering another word.

The same evening, a very heavy rain was falling when David closed the store. Due to a mass transportation strike, it was impossible to get a cab, or take the bus or the subway. So he tried hitchhiking. Before long, a black car stopped in front of him. David opened the front door, looked inside and saw a woman in the driver's seat. She asked him where was he going and then told him to get in. David sat next to her as they crossed Central Park.

During the trip, there was little conversation beyond small talk about the strike and the weather. Though David sensed there was someone else in the back seat, he preferred not to look. When they arrived at his place, David thanked the woman. She didn't say anything back but just looked at him with the same piercing gaze as the woman he had encountered earlier at the store.

David ran into his building.

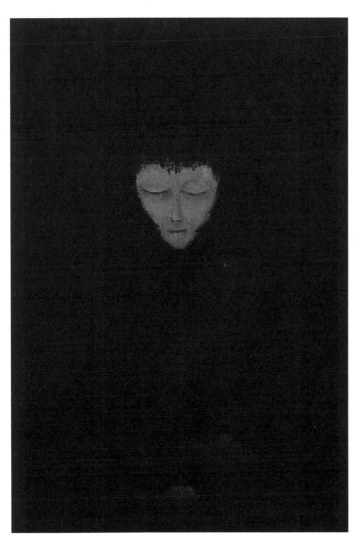

A Face in the Darkness

The night, David had a strange dream of a woman's face in the darkness. Her eyes were closed and her skin was very pale. It seemed as if the face were floating in the air. As the hovering face drew closer to him, his mind went blank. Later, David would wonder whether the woman who had come into the store, the one who given him a ride, and this woman in the dark were one and the same: Crescent.

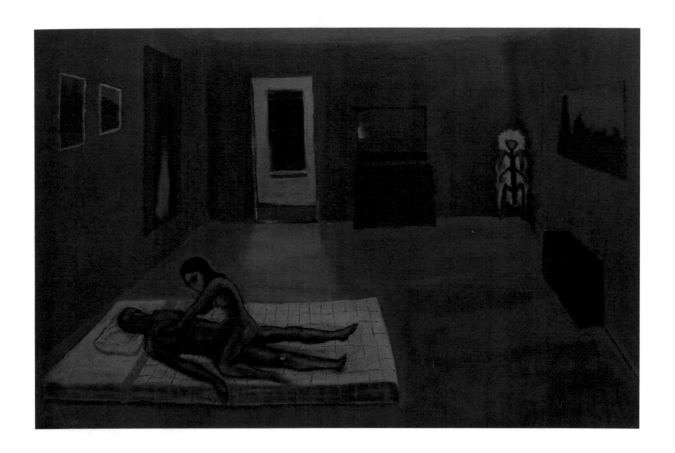

In My Room

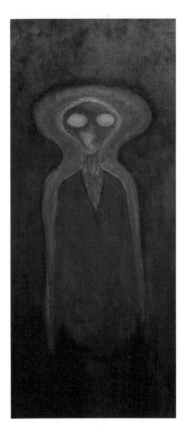

During the following nights, David had the same dream again and again. The pale-faced woman became a constant visitor in his room. But each night she became a bit more real. And each night the dream progressed a little more. And so did the surroundings. At first it was just the woman in a darkened room. There was a soft glow in the corner. At times the dream was sharp and clear, other times not. After a while, these dream visitations became what David now calls the "sex dreams," when Crescent came to his room to have sex with him. Though these experiences were very intimate, they were not alone during these nocturnal encounters. The Insectlike Being was always with them, observing from a corner.

David was not the only one experiencing strange visitations. Around same time, his young girlfriend, Ethel, had a very disturbing experience in her apartment. One night she woke up and saw a group of little men around her bed. She was so scared that she ran out the bedroom screaming for help. Her neighbours checked the apartment but they couldn't find anything. The next morning she packed her belongings and left New York City forever. David never heard from her again. It seems the visitors wanted him exclusively for themselves.

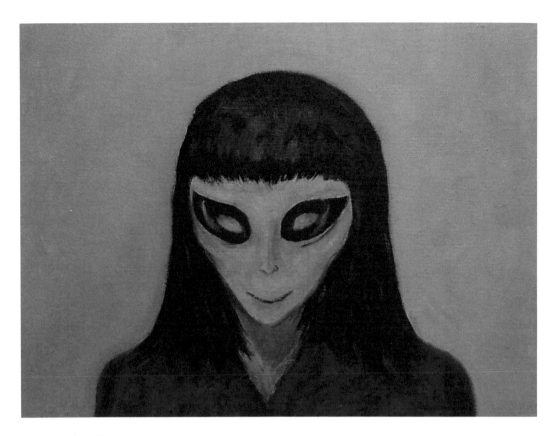

Her Hypnotic Eyes

The morning after one of those "dreams," David woke up and heard somebody talking to him. "We'll be back tonight," the voice said very clearly. As promised, Crescent came back that evening.

Crescent's night visits became a routine part of David's life. For at least five years, she would visit him twice or three times a week. What David was experiencing with Crescent was much more real than "normal" sex dreams. They felt completely genuine to him. But David still didn't know whether Crescent a dream, or a real woman.

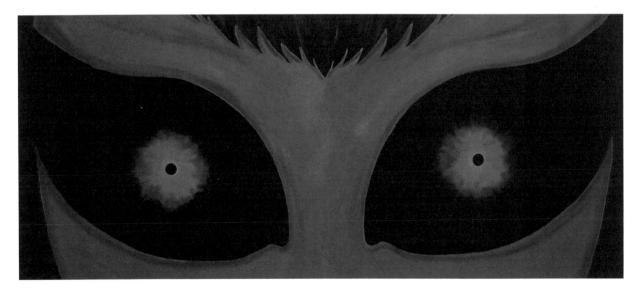

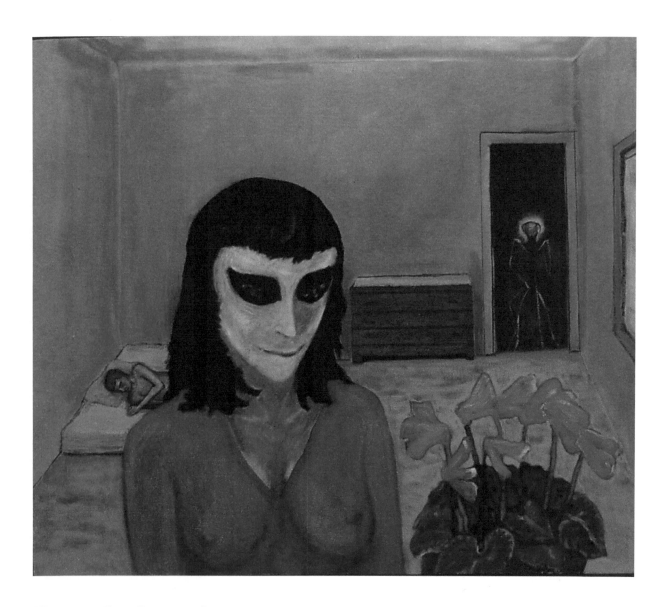

Flowers for Crescent

One evening, while walking home, David spotted some beautiful cyclamens in the window of a flower shop. Flowers for Crescent? Why not? "I'll get the flowers for her," David said to himself. "If she takes them tonight, I'll be sure that she is real. If not, I'll use the flowers as a model for a painting."

He came home, put the flowers on the bookcase, and went to bed. The next morning he didn't remember anything about the previous night, including his purchase of the flowers. Before he left the apartment, he passed the bookcase. That triggered a hint of a memory. What had he put there the night before? He couldn't remember and left for art school. There, he visited one of the studios where there was a watercolor painting class in progress. The young artists were painting several floral arrangements. *Flowers!* The memory came back. Crescent had taken flowers before she left. She was real.

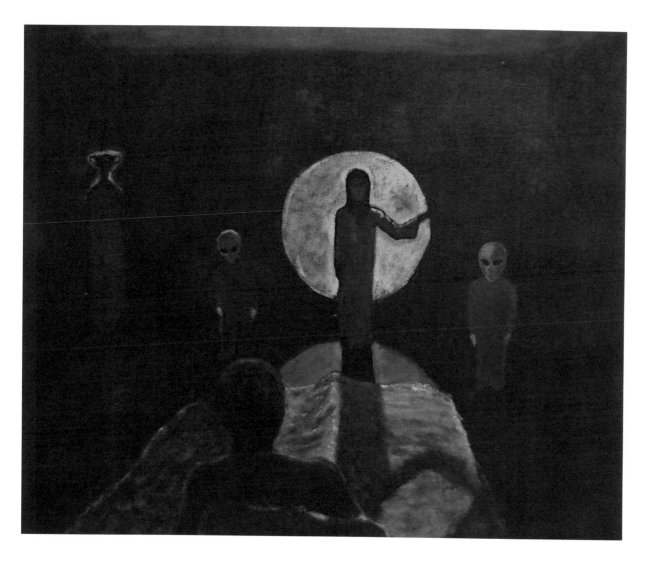

Waiting for Crescent

That night as he went to bed, David noticed something strange on the wall facing the bed. It started as a shiny dot the size of a quarter. David felt a strange energy through his being, as if his consciousness was altered, though he was alert and conscious. His apartment became strangely quiet, unaffected by the Manhattan din, and as the glowing spot on the wall became larger, it finally opened up. In total silence the Insectlike Being came through the opening, followed by Crescent. She approached David, and he felt a very pleasant energy from her. She sat on the bed, looking first to the bookcase and then looked at David, smiling.

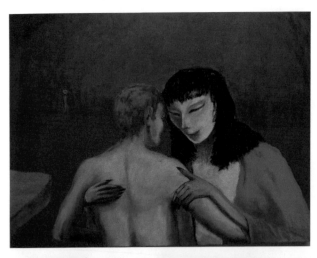

Kissing

Crescent got closer to David's face and started to rub her forehead to his. David knew that this was "kissing" in her alien world. It was such a deep and warm feeling. He felt there was a special bond between them.

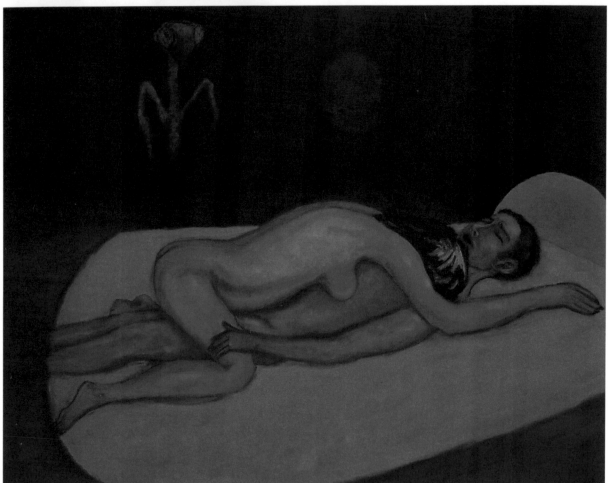

Falling in Love

When they started to make love, David was surprised that everything felt much deeper, even romantic, between them. Yes, they loved each other. Crescent lay down on David's body and she started to make a very soft, melodic sound like a purring cat. David closed his eyes and listened to her for a while. When he opened his eyes, she got up. All the while, during this intimate moment, the Insectlike Being was there, observing them.

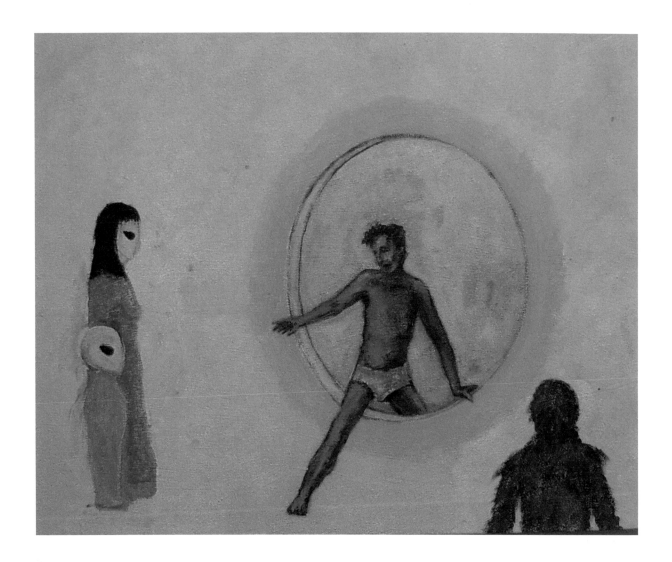

Visiting the Other Side

David was curious about the circular opening on the wall. When he got closer, Crescent looked at him, as if saying, "If you would like to go, go ahead." David quickly passed through the opening. When he turned, he was able to see his own bedroom from the other side. Crescent and the Insectlike Being followed him through the opening.

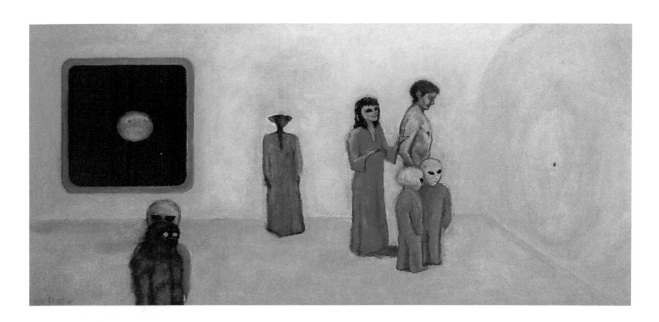

When the Opening Closes

Once everybody was in the other side, the opening between the two dimensions closed immediately. From the window he was able to see the Earth from a distance. David could not understand how they could come to this distant place in just a few seconds. Later, when David returned and the gate closed, it was as if the gate had closed on David's visitations. Weeks passed before David would see his nocturnal guests again.

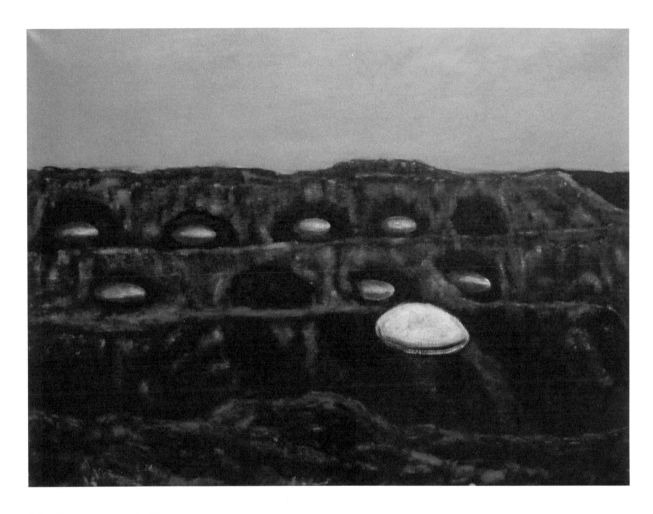

Underground Caves

David had a **dream** in which he saw a natural cave system with many UFOs going in and coming out. It appeared to be some kind of underground facility, and looked like it could have been on our own planet. David calls this place the "parking lot."

MY BABY

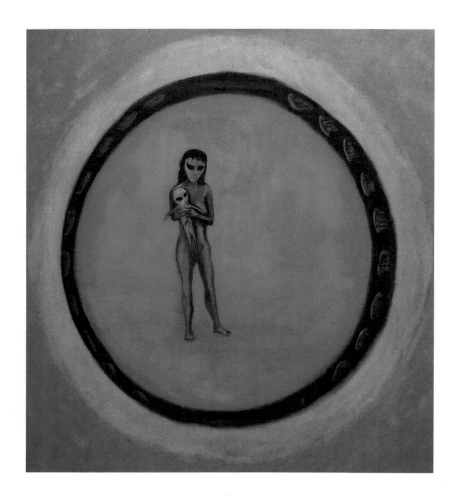

Your Baby Is Dying

It was a quiet afternoon. David was painting in his studio. Suddenly the interdimensional door started to open on the wall. David had a visitor. It was Crescent, looking at him and seeming very upset.

"David, the baby is dying," she said.

"Baby? What baby?"

David didn't understand. Crescent showed him a very small Gray baby, holding it under its tiny arms. "Your baby, but it is dying."

David yelled desperately not to hold the baby like that. "You must cradle the baby in your arms," he said. He wanted to come to the other side in order to help, but Crescent said that it was not allowed and he could not go there. David was insistent; he needed to save the baby's life. He lay down on his bed, fell asleep, and the next thing he knew, he was *there*.

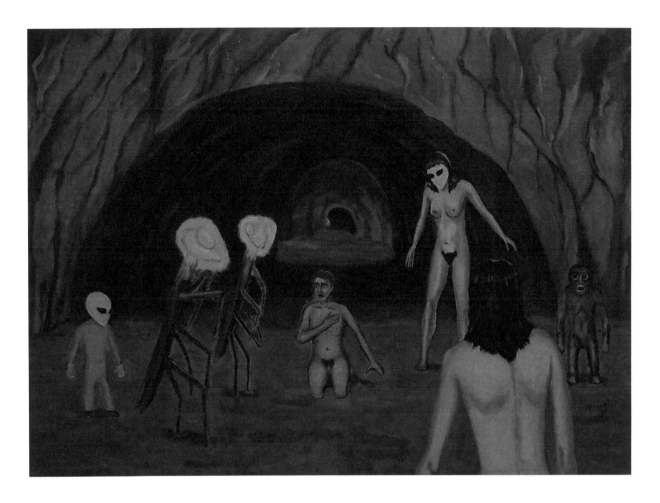

Underground Meeting

David found himself in a kind of underground cave complex, astonishingly different from the previous spaceship experiences. Crescent, other Hybrid women, Grays, and Insectlike beings were there too. One of the Insectlike beings came to him and asked what he was doing there. David told him that his baby was dying and that he must see and touch him. David had to beg on his knees until the Insectlike being agreed to let him hold the baby.

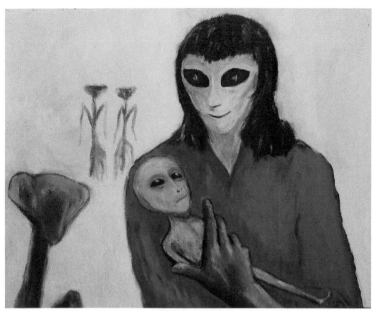

Touching the Baby

At first, the tiny creature seemed very weak, almost lifeless. But with David's warm touch, it started to move. A kind of electrical spark passed from David to the baby, and the baby's health seemed to improve immediately. Everybody seemed happy and excited by this development, surprised to see that the human touch could cause this seeming miracle.

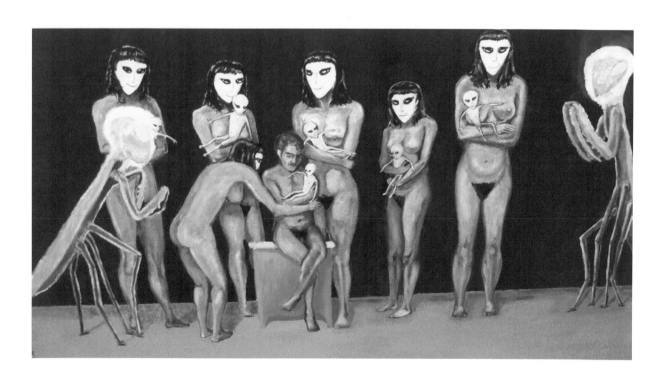

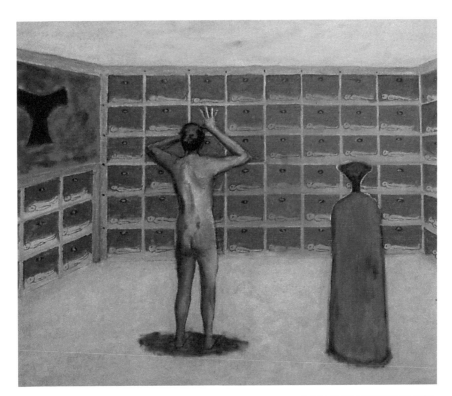

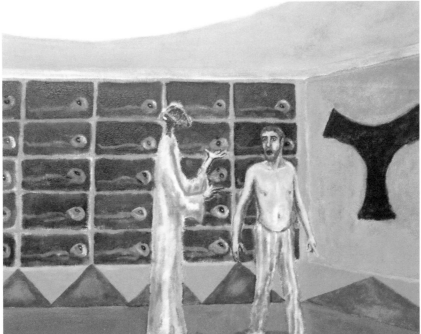

Visiting the Nursery

Insectlike Being took David to another room, a huge nursery, or as David calls it, an "Incubator room." The walls were covered with hundreds of small containers, each one holding a little Gray baby. On the other side of the wall there was a large machine making a strange humming sound. Insectlike Being told David that they were his babies. He was there to touch the babies and give them the life energy.

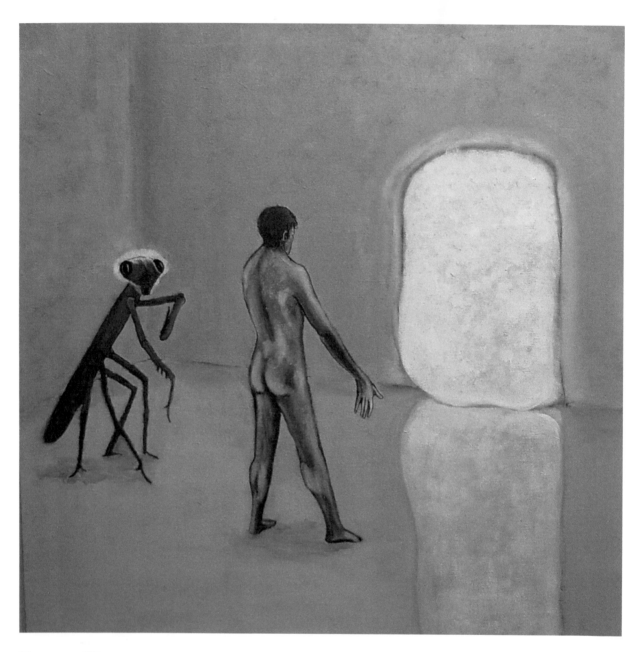

Energy Therapy

David felt extremely tired and weak when he woke up the next morning. He stayed in bed sleeping all day. But late at night he woke up to another strange experience. Insectlike Being was with him. Together, they walked towards an opening that was shaped like a door through which shone a very bright and pure light. Insectlike Being told David to go inside the light. At first he didn't want to. But the being insisted, and David walked into the light source. He stayed there a few minutes before being sent back to his bed. The next morning he wasn't weak and exhausted anymore, and he felt extremely energetic and healthy. This feeling lasted for weeks.

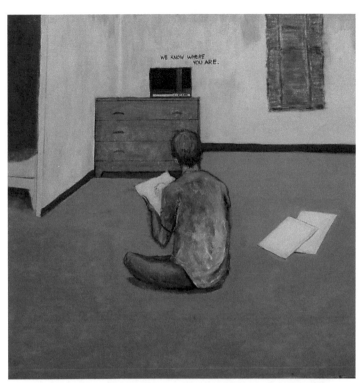

We Know Where You Are

A month passed. David had moved to a new apartment. During the first few months in his new home, there were no encounters. But one night, while listening to the radio, David heard a voice:

"We know where you are…"

Did the voice speak to him? No, it was just the radio. But no matter how he tried to explain it, David could not banish the certainty that this strange voice had been speaking to him directly.

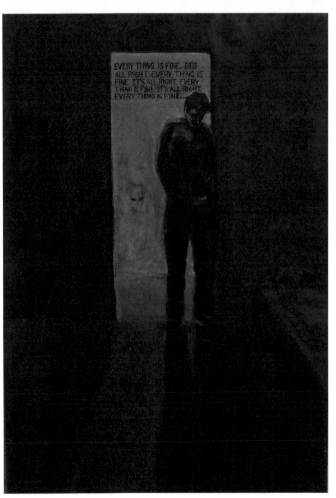

Everything is Fine

Suddenly David felt very sad and depressed. Then he heard the voice again, repeating the same words: "Everything is fine… it's alright. Everything is fine… it's alright."

David mechanically took off his clothes, lay down on the bed, and began to cry… without knowing why.

A GREAT SADNESS

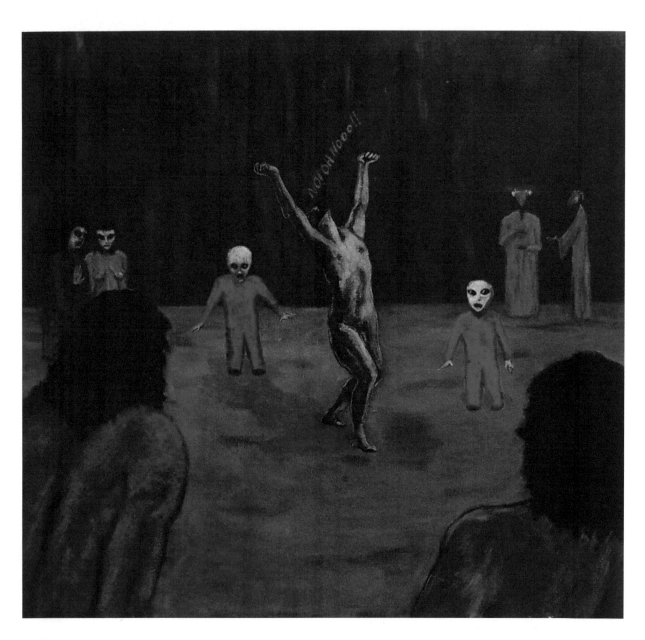

Grief

David jumped up and began screaming: "No, no, no!" over and over, while the voice kept repeating the words: "Everything is fine… it's alright." But everything was not alright, because David was no longer in his bed. Now he was in the underground place he had visited some time before. Two large hybrid women came and tried to hold him under his arms. Crescent tried to calm him. Then David realized why he was so crushed with sadness: he believed that he had dropped the baby and caused his death. He wept uncontrollably, saying that the baby died and it was his fault.

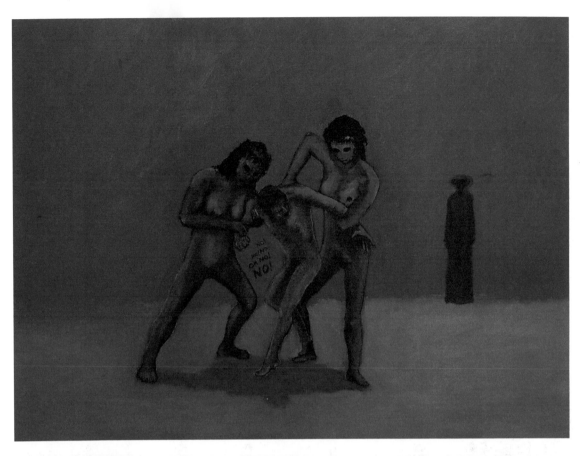

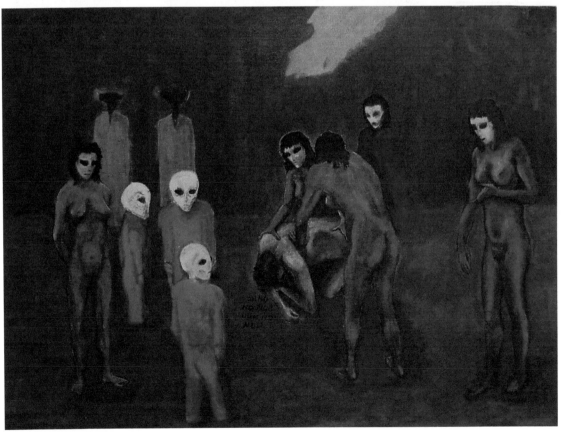

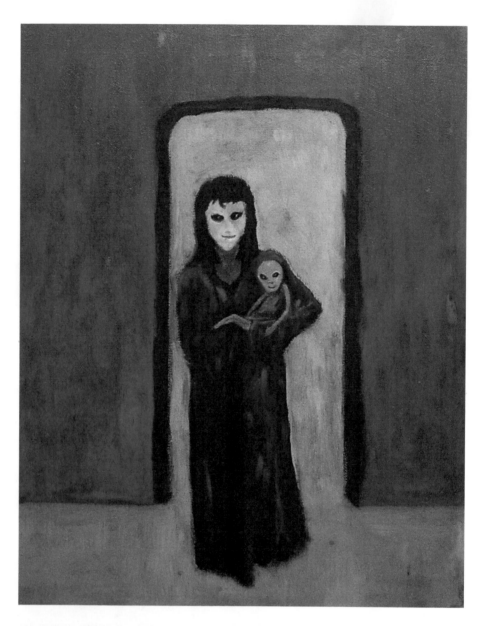

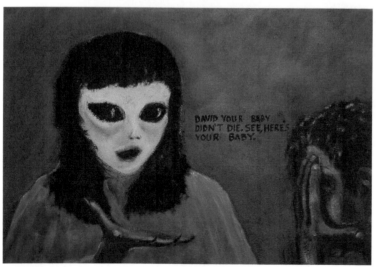

Here's Your Baby

But Crescent then said, "David, your baby didn't die." David looked up at the door and saw another Hybrid woman bringing the baby, cradled in her arms. David rushed to the baby and was relieved to see that he was alive and well.

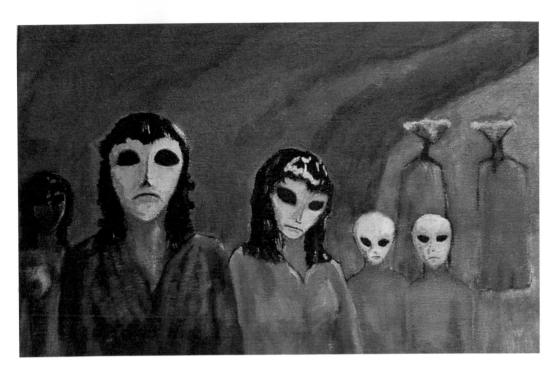

Frustration

The Hybrids and Grays were surprised by David's reaction, as if they were not very familiar with deep human emotions such as fear, sadness, or sorrow. When they saw him sad and crying desperately, they also became upset and scared.

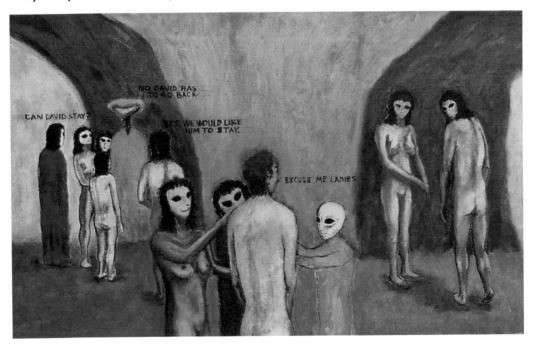

Can David Stay?

David felt embarrassed over his extreme reaction and apologized to them. They smiled and let him know that it was alright. Two large Hybrid women then asked Insectlike Being if David could stay among them. His answer was very clear: "No, David must go back."

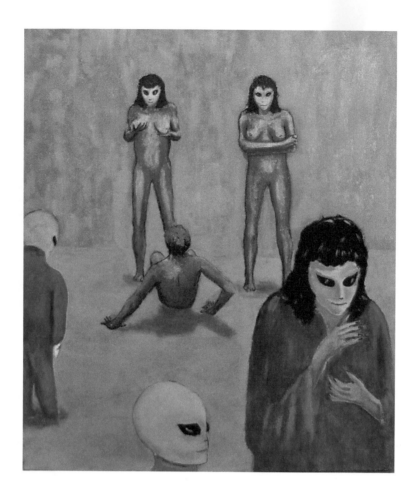

Body Language

The two Hybrid women appeared frustrated so David repeated his apology. One of the women then put her hands under her breasts and raised them up, as the other crossed her arms under her breasts and lifted them up. The meaning was clear in any culture; the Hybrid women wanted to have sex with him. They were not shy at all.

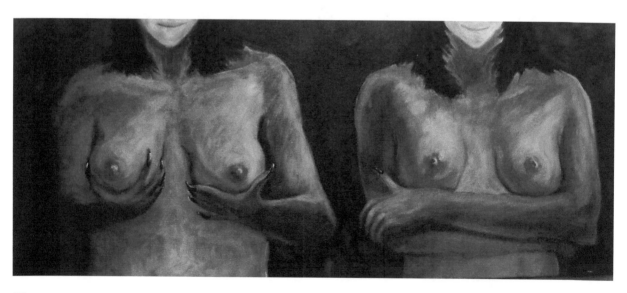

LOVE IN AN ALIEN PURGATORY

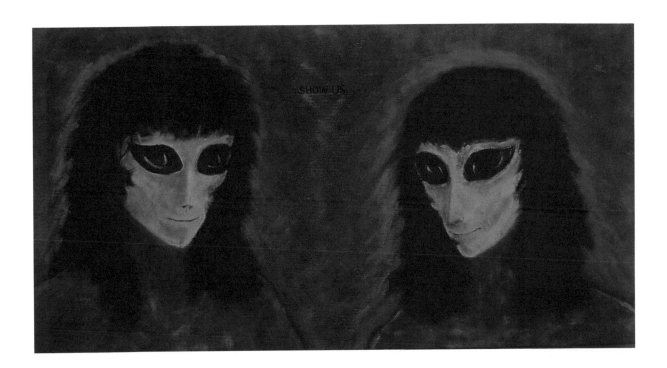

Show Us

Although he was not prepared for what he was asked to do, David didn't want to hurt anybody's feelings. When he asked, "Can we be romantic?" he heard somebody say, "Show us!" They wanted him to teach them how to make love as humans do, expressing feelings. This expectation opened a new stage in his experiences with the visitors: David was now their teacher.

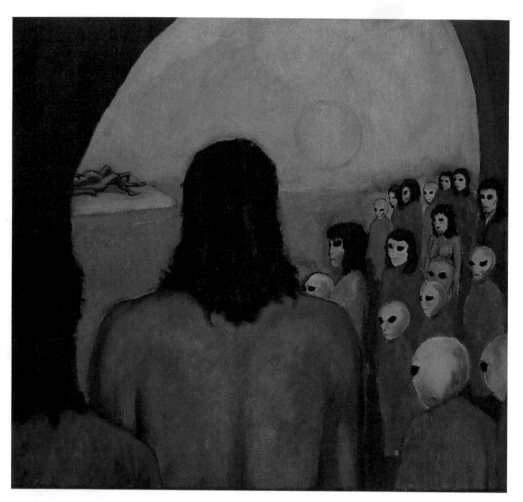

Privacy
David was ready to teach them, but there was a problem. The audience was greater than David could handle. "Can we have a bit of privacy?" he asked. The crowd of aliens then turned and went away.

David made love with one of the Hybrid women with passion and sensitivity. He showed her how to kiss, how to stroke, how to be gentle in a sexual relationship. All the while, the other aliens watched from a discrete distance.

The Light on the Ceiling
At one point, while lying next to the Hybrid woman, David looked up and saw an intense yellow light coming from an opening in the ceiling. David felt as if he was being pulled towards the light. This was his last memory before passing out.

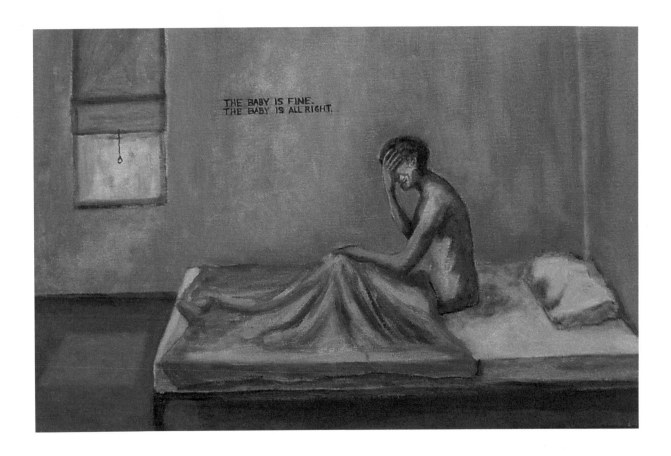

THE BABY IS FINE.
THE BABY IS ALL RIGHT.

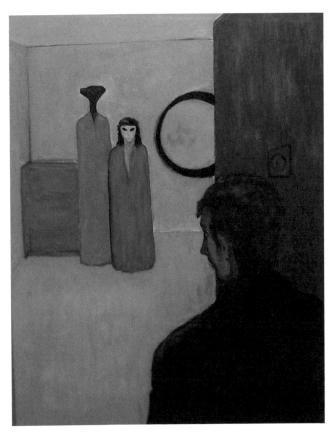

The Next Morning

When David woke the next morning, he heard somebody saying, "Baby is fine... baby is alright." And for the next couple of hours he was allowed to remain aware that he was a father, the father of numerous hybrid babies. Then he forgot everything again as he had been programmed to do.

We Are Waiting for You

Two days after this emotionally intense experience, David came home to find both Crescent and Insectlike Being there waiting for him. They had apparently entered through the open circular gate on the wall. Why were they there in his home? David would soon find out. They wanted him to make love with the second Hybrid Woman as well.

TRANSFORMATION

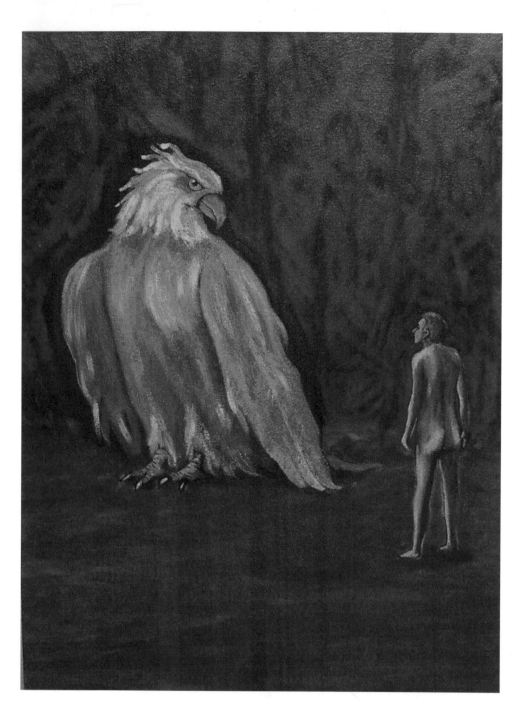

Phoenix

David's unusual experiences were not limited to ETs and Hybrids. One time he had an encounter with a giant bird that he describes as the Phoenix. After he fell asleep, he was taken to an underground place. He found himself in front of a giant golden bird with shining feathers.

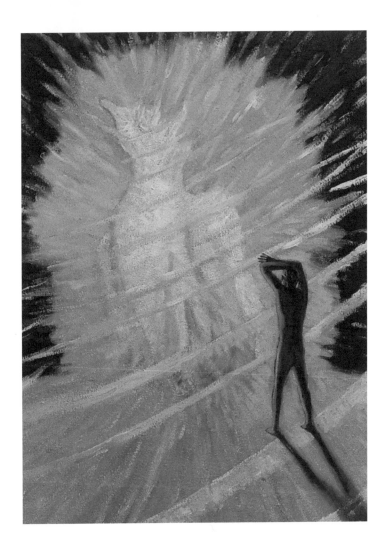

Flames

While trying to understand what this creature was and why he was in its presence, the giant bird suddenly burst into flames. David tried to shield his face from the intense fire and smoke.

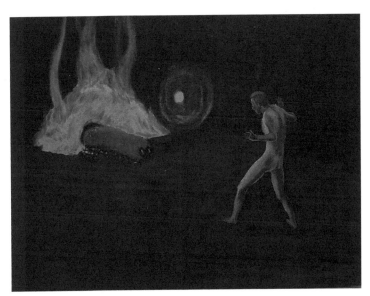

The Worm

The fire burned out quickly and left a pile of ashes. David saw something was moving inside the ashes – a giant, dark colored worm. David did not understand why he was being shown the Phoenix. Was this a symbol of his own transformation?

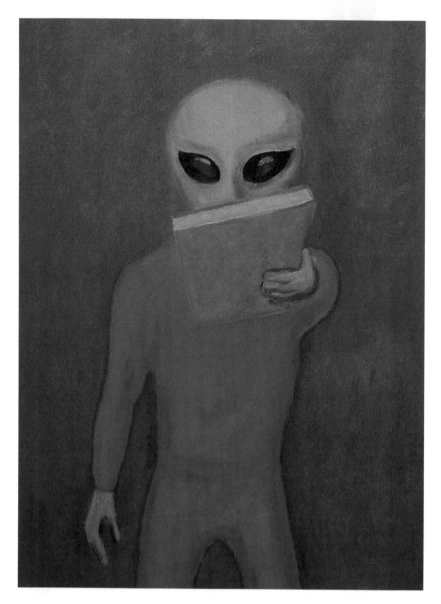

Gray Alien Gives a Book

Some time later, David had another meeting at his home with a Gray. This time, the visitor gave him a book. David describes its pages as a brilliant, luminous white. At first its pages were blank. But suddenly, images and diagrams started to appear, then disappear again.

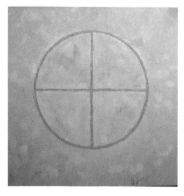

The Symbol

The next day David searched his apartment for the book but couldn't find it. The visitor had taken it with him. David could only remember seeing one page: on it was a circle with a cross inside it.

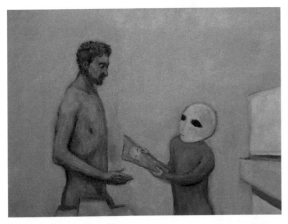

The Package

David's next meeting with the Gray alien took place in a room that appeared to be part of a spaceship. The Gray handed David the strangest thing he had ever seen: a transparent plastic bag with an alien being inside.

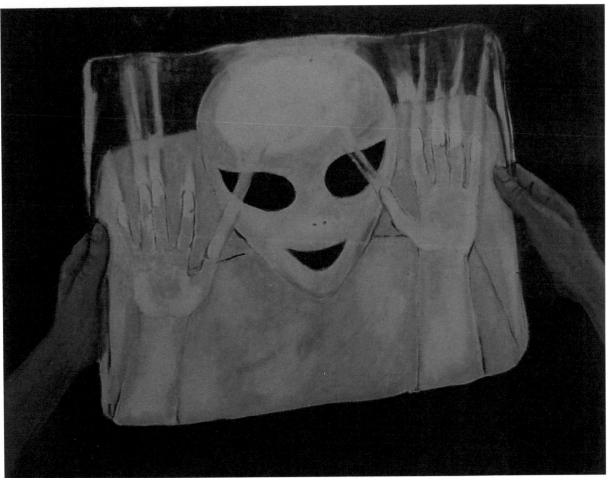

ET Wrap

The Gray alien inside the package moved and tapped at the inside of the bag. Its eyes and mouth opened. He seemed alive even though he was folded and wrapped. David didn't want to hold it anymore and gave it back immediately. He was made to understand that this was the body skin coverings that Grays used. Some time later, David was retouching this painting and had a question: "Do they still use these bodies?" That same night he had a dream that he was with several alien beings who looked quite human. One of them answered David's question: "We have new bodies now."

REMEMBERING

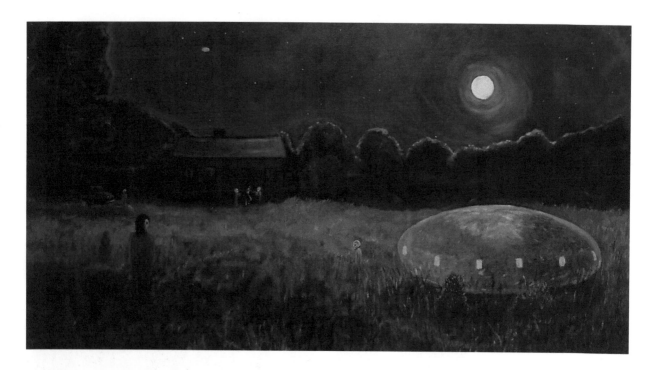

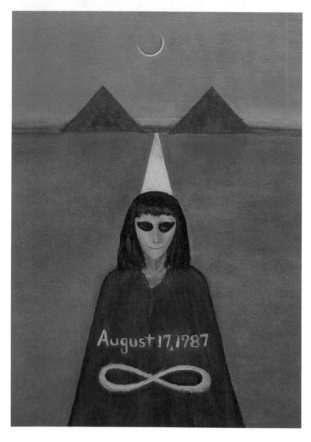

August 17, 1987

In the early 1970s Crescent told David that they were going to leave him alone for a while. She said they would come back on August 17, 1987. Until then he would forget everything that he had experienced with them. After that, David went on living the life of a normal young man in the city. He finished art school and got a job. Later he got married to a young woman. From this marriage they had a son. Over the years David had a vague memory of the given date, but he had no idea why the date was so important. Then one day David was listening to a radio show about the Mayan Calendar and the Harmonic Convergence, though he had no interest such topics, and suddenly they mentioned August 17, 1987, which was just a few months away. On August 17th, David had a dream about something descending from the sky and landing. A woman came out of the object and started to walk towards David. It was Crescent.

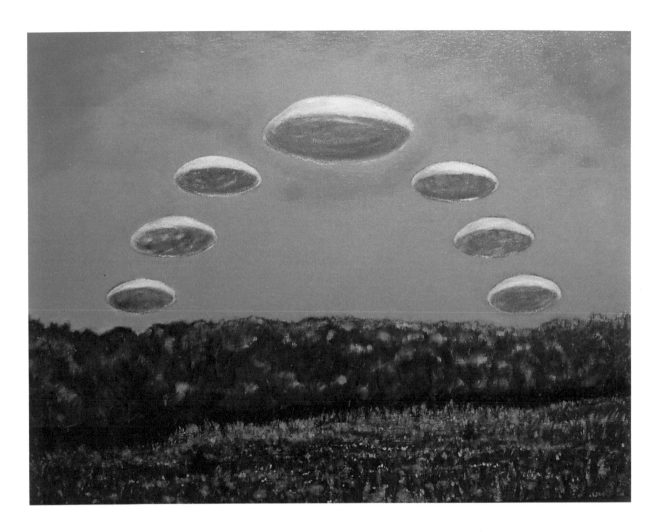

Testimony in Paint

After that dream, many things changed in David's life. He became depressed, convinced that something serious was amiss in his life or spirit. He started to get up in the middle of the night, searching closets or outside the house, thinking there were people around. Although he didn't see anybody, he felt that people were following him secretly.

One day he was in a bookstore and began reading a chapter called "Other Women, Other Men" in a book written by Budd Hopkins, the abduction researcher. Suddenly David remembered everything. One by one, the encounters spilled into his mind and filled the spaces they had left.

David could now remember everything about his ET encounters, all the way back to his childhood. He had a strong feeling they wanted him to do paintings about his experiences with them.

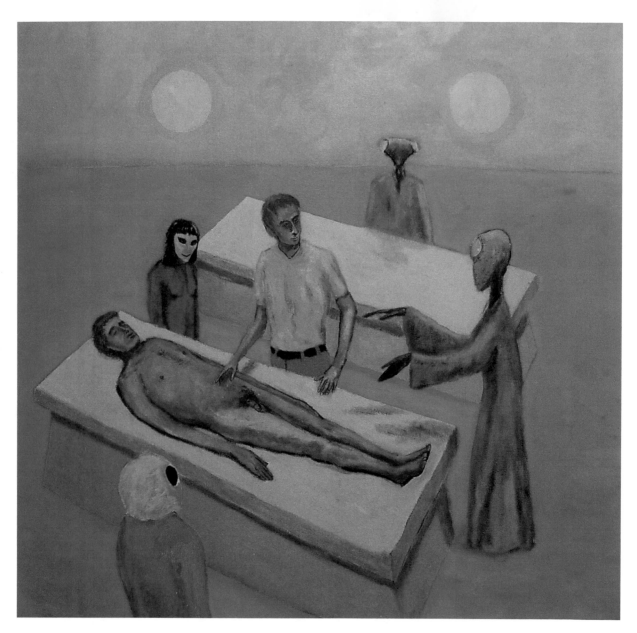

David's Copy

Meanwhile more dreams, visions, and encounters took place. A couple of years later David found himself in a place that resembled the interior of a spaceship. He was taken to a room where there was a man lying on a bed. When David got closer, he saw that it was a copy of himself. Though David was around 60 years old, this copy was a much younger version of him. But it was motionless and didn't look alive.

While he was trying to figure out what was happening, they asked him, "Can we use your body, David?" He said yes. They told him to lie down on the other bed. Shortly, the young body started to move and came to life, as if they had used David's life energy to make the other one function. David wondered if this new, younger copy would be used in further genetic experiments.

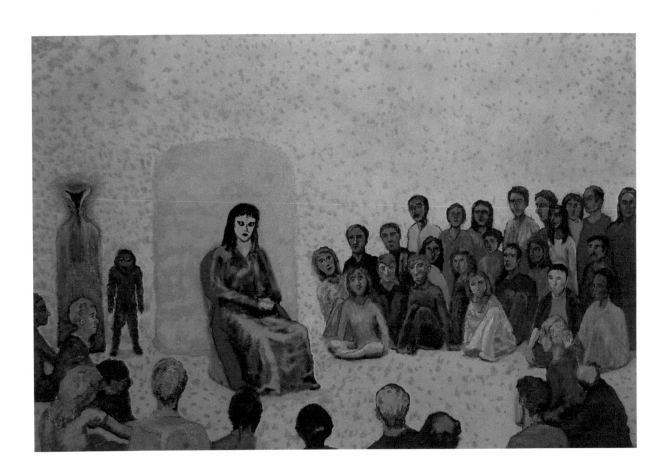

Big Gathering

Another time, David was taken to a meeting. He saw Crescent sitting on a chair and talking to the crowd. David was surprised to see other humans among them: individuals of many ages and races. This was the first time he would see other people from Earth during an encounter.

Mother's Visit

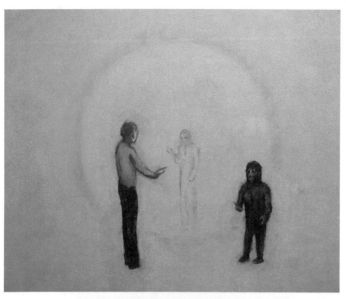

One day in 1991, while David was in Pennsylvania, he had a vivid dream in which a very bright light came through an interdimensional opening on the wall. First, Hairy Guy stepped into the room. Behind him David saw his mother. He told his mother that he loved her, and she said that she loved him too. They then said goodbye, and David woke up to the telephone ringing. It was his brother. He told David that their mother had been in the hospital and had passed away fifteen minutes earlier.

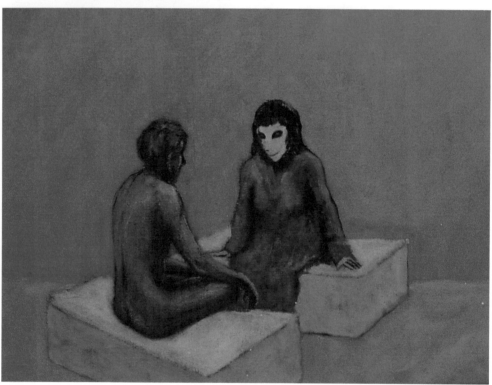

Conversation With a Friend

Crescent and the other ETs became a very important part of David's life after he recovered his memories in 1987. He poured his memories of the encounters into his paintings, and new memories continued to surface.

David recently recalled a place where he and Crescent were sitting and chatting. He knew that Crescent was getting ready to tell him something important, and looked happy to give him this information, information that would somehow bring closure to the mystery of their lengthy relationship.

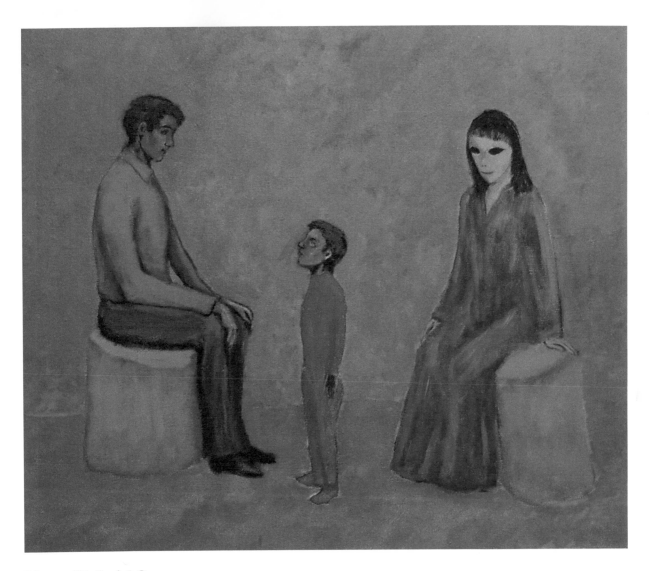

Your Hybrid Son

Later, David had another meeting with Crescent. This time she brought with her their Hybrid son. This was the first time David was shown one of his half-human, half-alien offspring.

David and his son looked in each other's eyes. They knew each other well.

EPILOGUE

Has David Huggins really been in contact with ETs his entire life? Is this story a real life experience or just an escape from daily worries and struggles?

To such questions, David replies: "I am not trying to convince anybody about my story. I just tell what I remember by painting pictures from different periods of my life. This is my reality… these beings became a part of my life since I was a young boy. If nobody wants to hear me, it is okay. If somebody wants to know, I am ready to share my story."

LOVE IN AN ALIEN PURGATORY

Index to Paintings by David Huggins

CPSIA information can be obtained
at www.ICGtesting.com
Printed in the USA
BVHW02n1741220818
524971BV00003B/31/P